MW00488382

THIS NOTEBOOK BELONGS TO

CONTACT

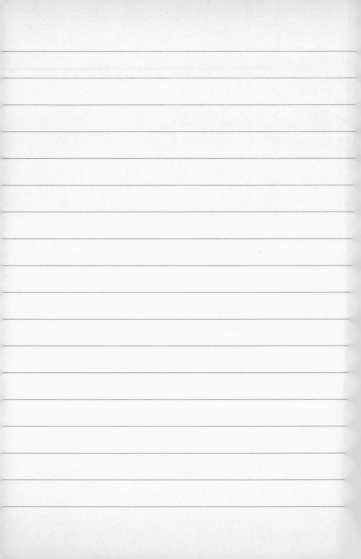

See our range of fine, illustrated books, ebooks, notebooks and art calendars:
www.flametreepublishing.com

This is a **FLAME TREE NOTEBOOK**
Published and © copyright 2017 Flame Tree Publishing Ltd

FTPB 35 • 978-1-78664-119-9

Cover image based on a detail from
The Star, or, *Dancer on the Stage*, *c.* 1876–77 by Edgar Degas (1834–1917)
© Peter Willi/SuperStock

Edgar Degas is perhaps most famous for his depictions of ballet dancers,
encompassing his ability to depict movement through art. This pastel figure
with outstretched arms, balanced on one foot, would have allowed Degas
to capture the muscular tone of the dancer's body.

FLAME TREE PUBLISHING | The Art of Fine Gifts
6 Melbray Mews, London SW6 3NS, United Kingdom